BRINGING UP THE ... PHAT

LAST GASP OF SAN FRANCISCO

Easy, Guess Free Growing
That Empowers You to Grow
Hydro, Soil, or Banzai Plants

BRINGING
UP THE
PHAT

Dedicated to those who won't give up.

Text and Art Copyright 2001 by Ana Baum
Published by Last Gasp of San Francisco
ISBN: 0-86719-511-8

Table of Contents:

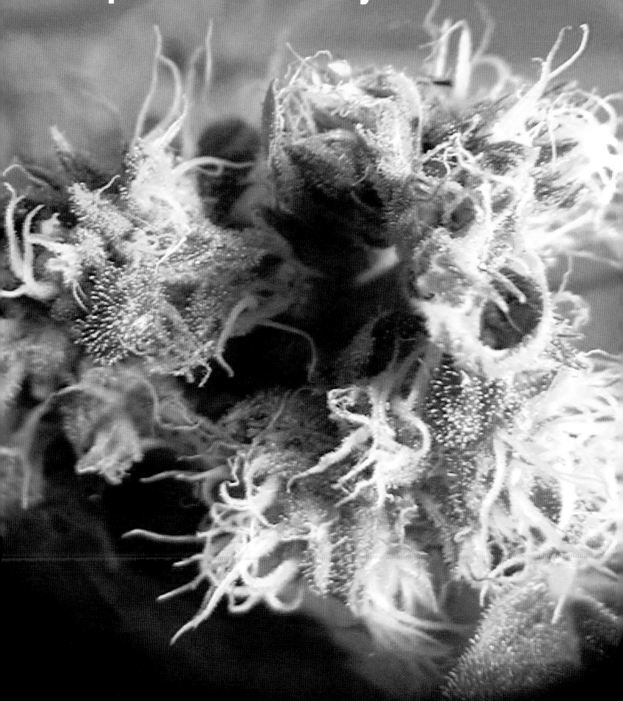

This book will show how to quickly raise
phat and sticky flowers.

TYPES OF PLANT

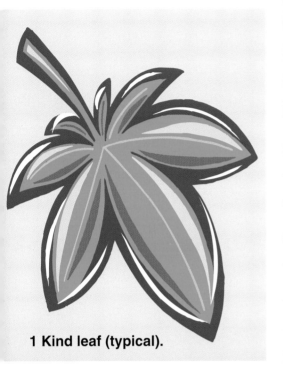

1 Kind leaf (typical).

2. Scwag leaf (typical)

 Be careful in which seeds you plant, as it is the difference between wasting your time or or reaping the rewards of potent fruits.

 Kind, potent plant's leaves are for the most part wide bladed and salady. The plants grow short and fat, and work well under artificial light and hydroponic applications.

 Thin, stringy leaves like those pictured below belong to the fibrous and less potent varieties. These are really only good to grow outdoors in a temperate to warm climate with a long summer. Usually a Mexican variety.

 It is best to know where the seeds came from, at best from a potent bag or a seed supplier. Select a good variety for your particular needs and space.

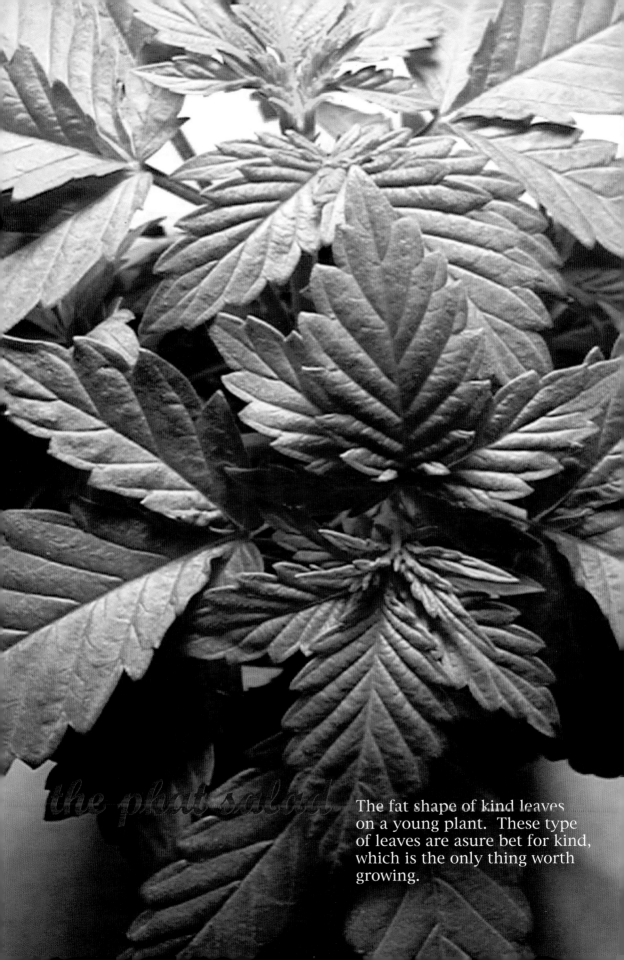

the phat salad

The fat shape of kind leaves on a young plant. These type of leaves are a sure bet for kind, which is the only thing worth growing.

PLANTING

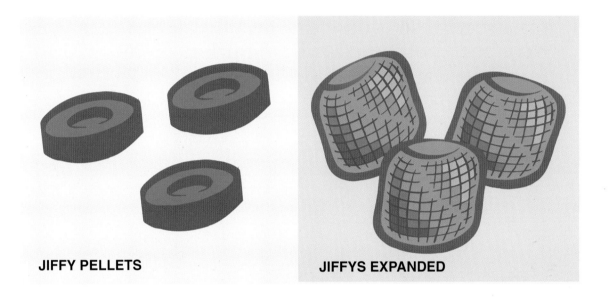

JIFFY PELLETS

JIFFYS EXPANDED

SEEDS

Planting is easy enough. Jiffy peat pellets are an easy way to start seedlings or clones with no mess. The pellet, which expands from a chip to a ball of sopping peat in water can also easily be transferred to either a soil pot or hydroponic application. Sprouts can also be made by putting seeds in between layers of moist paper towels, then planting the sprouts in a jiffy or right into it's intended pot.. In humid climates watch for, and change the paper towels, if mold appears. Wait until first leaves have formed until giving the seedling any fertilizer.

Do not underestimate the power of a few seeds, as one female plant can be cloned many many times and fill an entire grow room with a homogenous female crop. One could put oneself through college with the well husbanded products of simply a few little seeds, and this has been done. After the first two weeks or so of being a seedling, the plants will switch to vegetative growth stage and add on mass and size so quickly you will forget they were small.

SPROUTS

PLANT SEX

The term "fairer sex" also applies to plants. FEMALE plants are the only plants which bear the potent fruits. The males produce pollen sacs, which are so much chaff unless breeding for a seed base is desired. Female buds which have been pollinated end up far less potent and full of seeds. In this chapter you will learn to isolate females.

Females must be kept **virgins**, in other words.

The thing to do is to detect males as early as possible and kill them off before their pollen sacs open and cause the female buds to seed. It is easy to get the males before their sacs open, the trick is to get them during vegetative stage to give the females more room to grow.

Plants will often give premature buds on the nodes during mid to late vegetative stage.

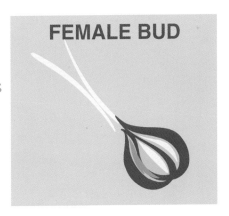

Look for premature buds at the nodes of the main stem, then the rest of the nodes.

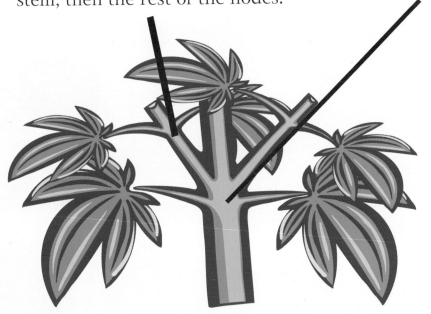

FERTILIZERS FOR HEALTHY PLANTS

For plants to yield forth the best crops it is absolutely necessary to provide for them the best nutrients available.

All fertilizers have an "N-P-K" rating on the packaging. This denotes the level of NITROGEN, POTASSIUM, and PHOSPHORUS, always in that order. In addition to these three elements, good fertilizers have micro-nutrients as well.

Two formulas will be needed, a grow formula and a bloom formula. For hydroponic applications buy a fertilizer specifically meant for hydro, as soil fertilizers are often lacking in the buffers and micro nutrient ratios needed for hydroponics.

Grow formulas are high in Nitrogen, bloom formulas are high in phosphorus. The plant needs nitrogen for putting on the poundage, then, during budding the plant needs the phosphorus to put out the big juicy buds that have so much potency.

Organic blends are good, and so are the techno supplements. Shop around, and settle on what you think works best. Every dime spent for premium fertilizer will pay off a hundred fold.

Life Cycle: Light/Nutrient Requirements.

Here is a quick general reference diagram of the plant's life cycle, and the cooresponding light and nutrient requirements.

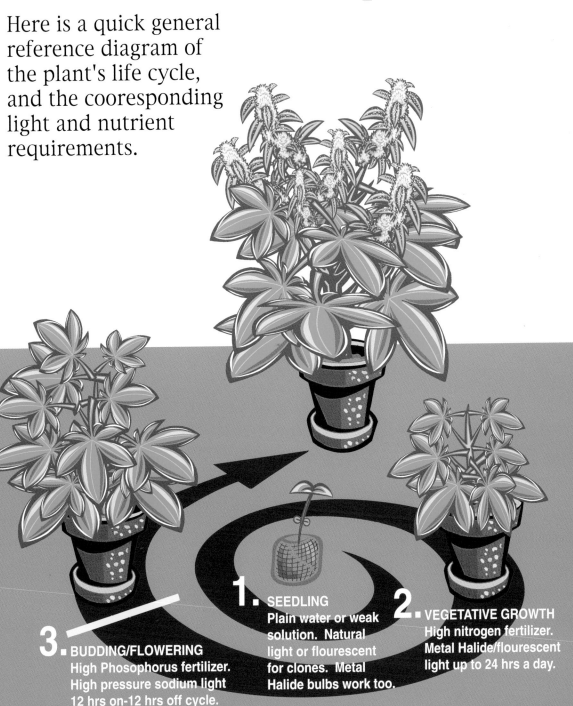

1. SEEDLING
Plain water or weak solution. Natural light or flourescent for clones. Metal Halide bulbs work too.

2. VEGETATIVE GROWTH
High nitrogen fertilizer. Metal Halide/flourescent light up to 24 hrs a day.

3. BUDDING/FLOWERING
High Phosophorus fertilizer. High pressure sodium light 12 hrs on-12 hrs off cycle.

NUTRIENT SYNERGY

The major nutrients, Nitrogen, Phosphorus and Potassium work with the micro-nutrients for optimum light, carbon and oxygen uptake. If everything is in perfect balance, the plant can absorb more of everything. Soils usually contain micro nutrients in spades, therefore fertilizers made for soils are less than complete for hydroponics.

Magnesium
Iron
Zinc

Phosphorus

For hydroponics, be sure to buy a fertilizer made specifically for hydro applications, as these have the correct balance of both major and minor nutrients for total plant growth.

Nitrogen

Potassium

Molybdenum
Copper
Boron

Potash
Sulfur
Calcium

Seedling Stage

As soon as the plant breaks the surface of the soil, it is no longer an embryo but a seedling. It establishes it's first couple of sets of leaves and it's root system.

With clones, the seedling stage corresponds with it sitting there for a few weeks until the clone develops roots.

When many seedlings are planted, and seeds are in good supply, it is good to kill off the ones that spring up almost supernaturally quick, as they are likely males. Conversely, kill off any that look very weak. A certain amount of preselect ion will help later, as you won't waste time on so many males and weak plants.

Vegetative Stage

The stage following the seedling, is one of tremendous - often explosive growth. The plant is putting on vegetative mass to produce many eventual flowers. The more massand leaf area, the more buds in the end. This period of accelerated growth is fueled by premium NITROGEN rich fertilizer.

If growing indoors, make sure not to let the plant get too massive for it's budding area, as it will get much larger in there as well. With many rich, fortified soils fertilizer isn't necessary until the flowering stage - or a weak solution can be applied. Be on the watch for over fertilization - this will burn the plant - retarding it's growth or killing it. If you do start burning your plants, pour some water through the soil to rinse out excess fertilizer. Start by pouring through an equal amount of water as the size of your pot and wait to see if it needs it again.

Budding/Flowering Stage

During the last stage, the plant gives up the goods.

It is during this stage that corresponds with the late summer and fall, that the plant needs PHOSPHORUS in healthy amounts. As said before, use a premium bloom fertilizer - preferably organic. Do not over do it however, as too much of a good thing will burn the plant, causing the tips and leaf edges to burn and turn brown, at worst shriveling the plant and killing it. Find a happy medium - start by using the maker's instructions, then try a little more and see if it gets any results.

During flowering, the plant will first enter a growth spurt, and just about double in height. After this spurt, the growth tips start slowing and leaf production turns to flower production. Apply the bloom fertilizer at the first sign of female flowers - at the first sign of male flowers, slaughter the plant and remove it from the garden.

CLONING: MANY PLANTS FROM ONE.

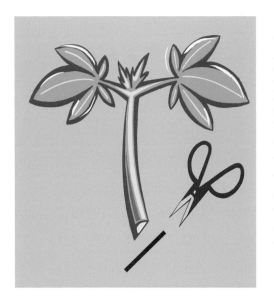

When you have identified a female plant, clone it vigorously until you have filled up your grow space with females. Keep taking clones from the clones before you put them in a budding chamber. Clones should be taken only from plants still in vegetative stage so it may be necesary to clone all the plants then kill off the clones that you then know will be male, working only with females once the initial sexing and culling of the males has taken place.

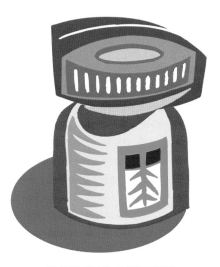

ROOTING POWDER

To take a clone, cut off the tip of a branch with one pair of leaves and one pair just forming at the top, as shown above. Make the cut with a sharp blade at an angle. Dip the cut tip in water then dip it in some rooting powder, following the directions on the package. Put the clone into a jiffy pellet to root. Clones root best under not too intense fluorescent light running 24 hrs a day. Keep the clones wet and they will root in 2-3 weeks and be a guaranteed female ready to vegetate and bud.

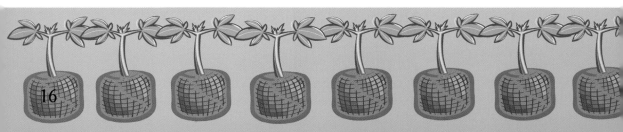

Taking a Clone

Select a healthy branch with new leaves at the top as well as a pair just starting to form at the tip.

Cut this branch off at an angle with a razor blaze, leaving as much stem as possible.

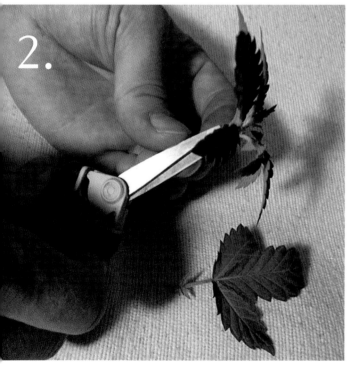

Clip off the lower fan leaves, leaving just the stem, and two sets of leaves at the crown.

Clip the leaves off, leaving the main stem of the clone.

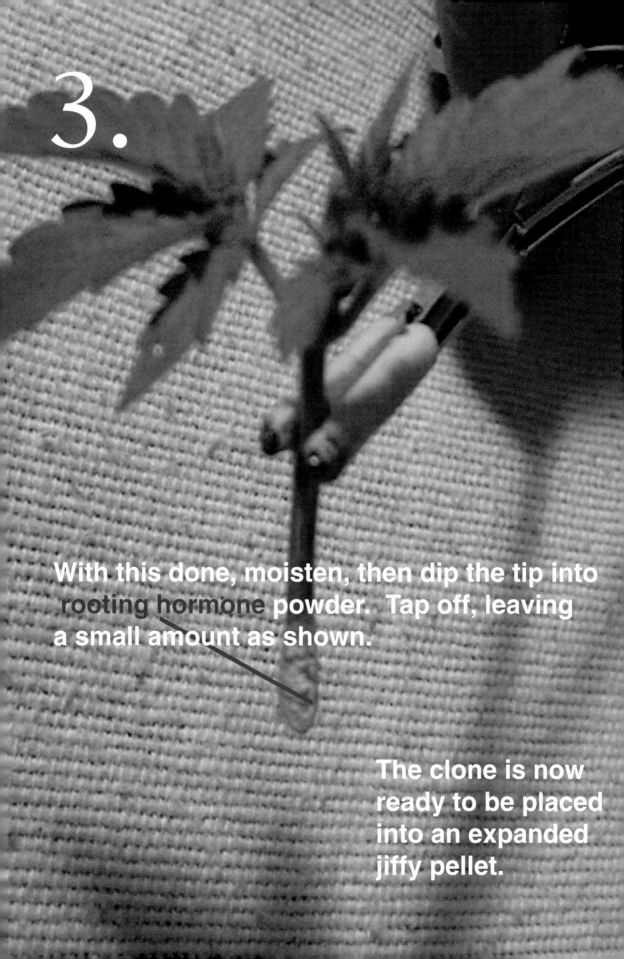

3.

With this done, moisten, then dip the tip into rooting hormone powder. Tap off, leaving a small amount as shown.

The clone is now ready to be placed into an expanded jiffy pellet.

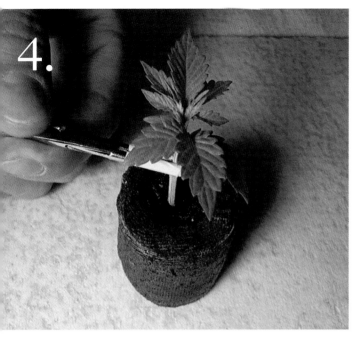

4.

Place the clone into the jiffy pellet. Make a hole in the top of the peller witha toothpick - just big enough to set the clone down in, without wiping the powder off the tip.

5.

Place the clone under fluorescent grow light running at least 16 hours a day, 24 hours a day works fine. If the climate is extra dry a humidity dome might be required. Usually, when the clone is first put in, it is shocked and it's leaves may wilt down for a short period - one day or less.Simply keep the clone moist and in 2-3 weeks roots will appear. A new plant.

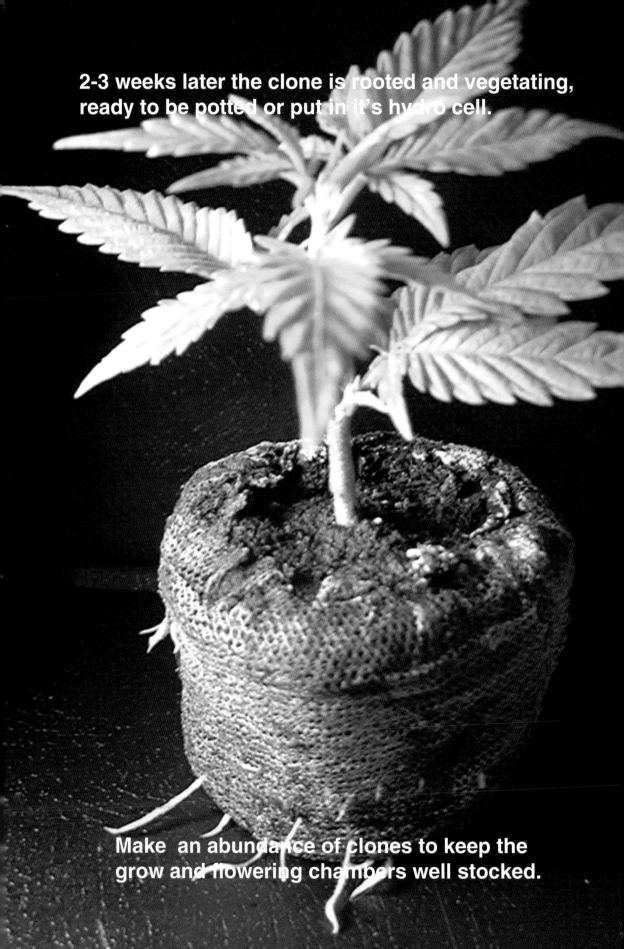

2-3 weeks later the clone is rooted and vegetating, ready to be potted or put in it's hydro cell.

Make an abundance of clones to keep the grow and flowering chambers well stocked.

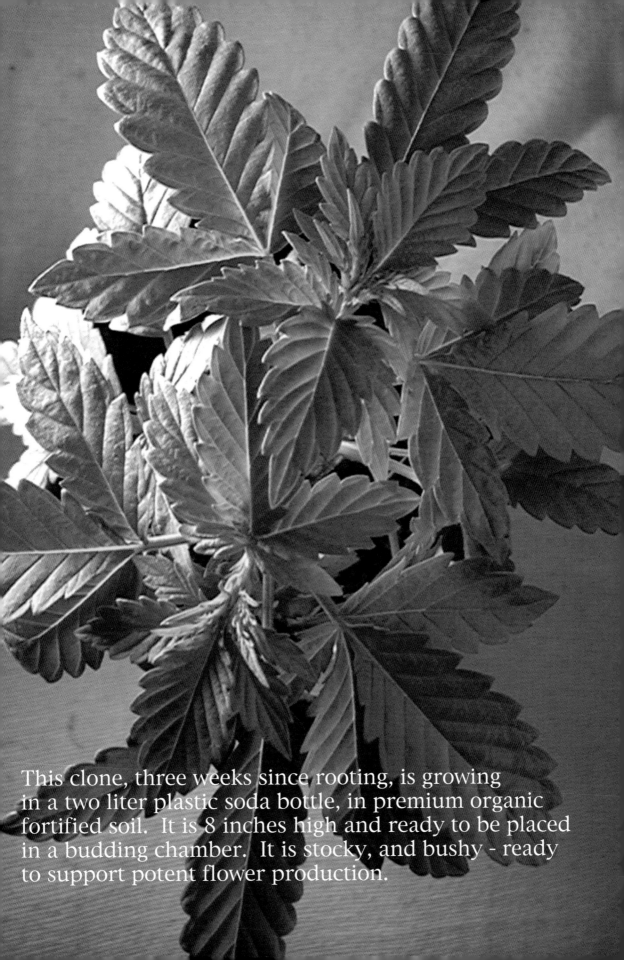

This clone, three weeks since rooting, is growing
in a two liter plastic soda bottle, in premium organic
fortified soil. It is 8 inches high and ready to be placed
in a budding chamber. It is stocky, and bushy - ready
to support potent flower production.

INDOOR
GROWING

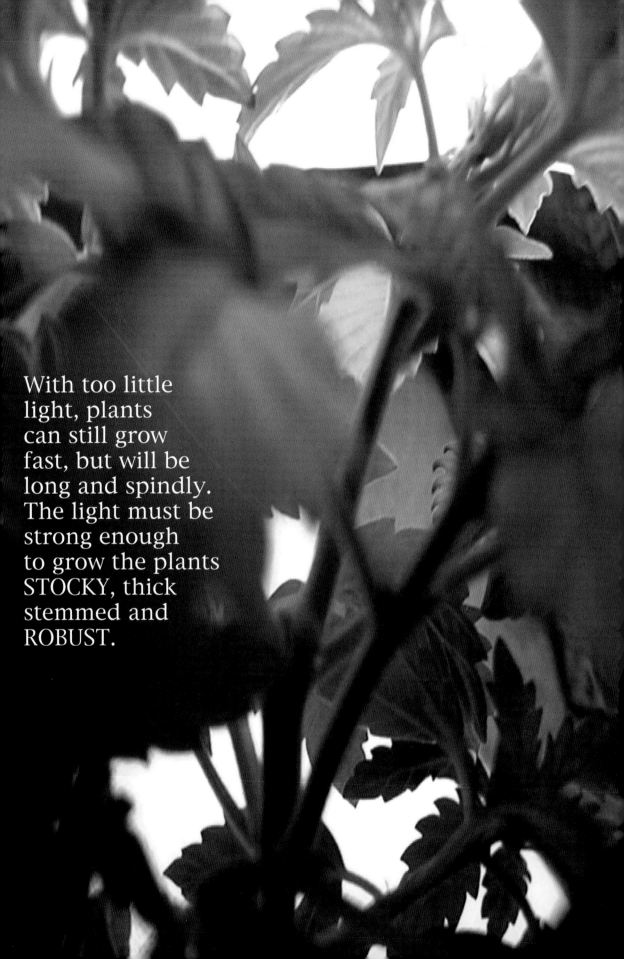

With too little light, plants can still grow fast, but will be long and spindly. The light must be strong enough to grow the plants STOCKY, thick stemmed and ROBUST.

FLOURESCENTS:

In terms of light output per watt, low heat and electricity consumption, flourescents are a good choice especially for cloning and growing if there is high pressure sodium is available for budding.

Flourescents come in many lengths and are ideal for lining small grow spaces such as cabinets and closets, because they are cool compared to HID lights or incandescents.

Full spectrum growing fluorescent tubes are sold and can be quite expensive. In order to attain full spectrum and also put out more intense overall light, use one cool white tube for every one warm white.

Fluorescent tubes are also by far the cheapest way to light a grow chamber.

HID LIGHTS

HID stands for high intensity discharge, and these are the best types of bulbs, indeed - the bulbs that produce the kindest of crystally plants.

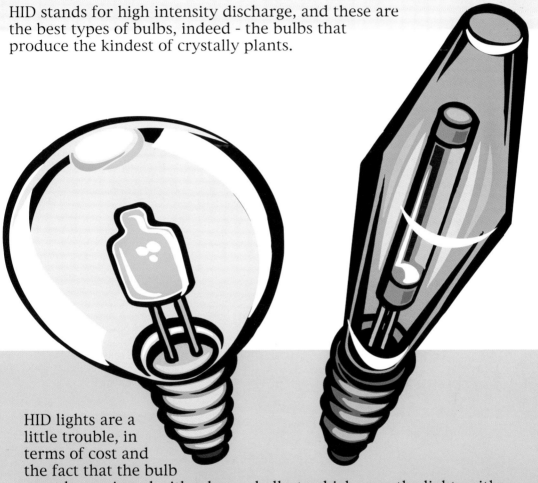

HID lights are a little trouble, in terms of cost and the fact that the bulb must be equipped with a heavy ballast, which runs the light - either a white METAL HALIDE light for growing, and or a HIGH PRESSURE SODIUM which provides orange and violet wavelengths essential to budding.

These lights are worth every penny, esp. if you are doing any type of real "gro-room" rather than a small area. Even small fluorescent powered setups should have a small high pressure sodium bulb to provide the correct spectrum for stocky, potent buds.

A good way to get a lot of yield is to clone the females aggressively, and transplant the clones to a flowering chamber after 2-3 weeks of rooted growth. Surround the grow area with flat white painted surfaces, or put up "space blankets" as reflectors, as shown below.

250 -400 watt high pressure sodium lamp.

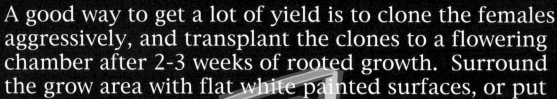

Quart or gallon milk containers filled with premlum soil.

This type "mini sea of green" can be used with milk-jug hydro bubble units as well.

In this flowering set-up, a small pyramid is made with an object elevating the most mature plant so that it's buds can bask in the most direct and intense light for a week or two before harvesting.

Any indoor garden must be ventilated!
This is accomplished preferably through
forced air, in order to regulate the temperature
as well as transport the pungent smell of
flowering plants to the outside, as they will
otherwise permeate a dwelling. Air is best
sent out the roof, above those who might
detect it. Computer fans work well for small
chambers, for larger grow
rooms use a bathroom
fan motor
with a good
fan blade
attached.

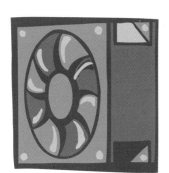

Use dryer ducting, or other type of tube to
duct the "green" air out. There are in-line
ozone generators available to treat air that
must be released where it could be smelled.

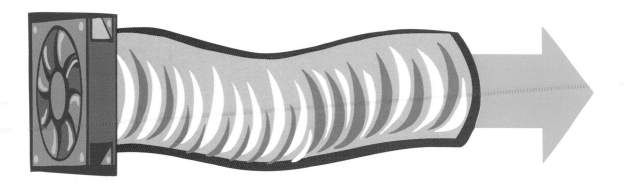

Here is a good way to vent out a window that is left open just a crack. Construct, out of cardboard, a nozzle that fits on the end of the tube, then flattens out like an oversized vacuum attachment. Place the long opening in the slightly open window and seal any leftover space with weatherstripping.

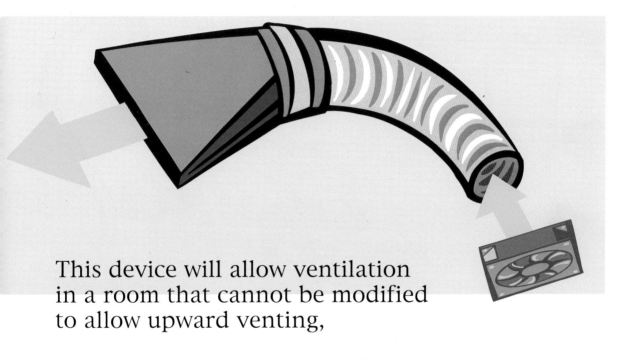

This device will allow ventilation in a room that cannot be modified to allow upward venting,

Other ways are to tap into the existing furnace venting, dryer vent, or chimney.

Make sure no light from the garden escapes from the vent hole, wherever it might be.

CO2 production

Carbon dioxide can be produced via a tank and valve timer, or with simple yeast and sugar water. Giving the plants more carbon dioxide increases growth and yield.

Fill a drinking glass 3/4 the way full with hot tap water. Dissolve into the water as much sugar as it will absorb. Wait until the water is warm, and pour in 1/3 packet of quick rise yeast.. This will charge a small grow-closet for 2-3 days.

Carbon dioxide is heavier than air and simply falls to the ground, put the CO2 outlet above the plants.

For a bigger CO2 generator fill a gallon jug 3/4 the way full and put in as much sugar as will dissolve. Put in one full packet of quick rise baking yeast. With the tube as shown, the outlet can be hung directly over a plant or plants, allowing the CO2 to waft down over the plants before eventually mixing with the air and being sucked out by the ventilation system. The CO2 tube tip can also be placed in the wake of a fan, dispersing it across the plants.

HYDROPONICS

Why hydroponics? Hydroponics is simple, cheap, easy and fun! A hydroponic plant is as simple to grow as any soil plant, and can be less susceptible to soil borne pests, like spider mites, which though easily dealt with, will occur in most soil gardens sooner or later.

With hydroponics there is less mess, and during budding the nutrient levels can be precisely controlled - giving more flower and less leaf.

The concept of hydro is to remove the soil as a growing medium and set the roots in an inert medium, then the roots awash in an oxygenated solution of pure nutrient proportions. This, as will be seen, is easy enough to accomplish. If there is no premium organic soil available, hydroponics is the way to go.

The Amazingly Easy
"BUBBLE-BOTTLE"
HYDROPONIC GROWING DEVICE

STEP 1. Stick a siphon tube {1/2" ACRYLIC TUBE} and some aquarium line **DOWN THE HANDLE** of a milk jug, or other plastic container with such a handle. Moistening the tubes helps if they stick. Push the tubes down all the way until they reach the bottom.

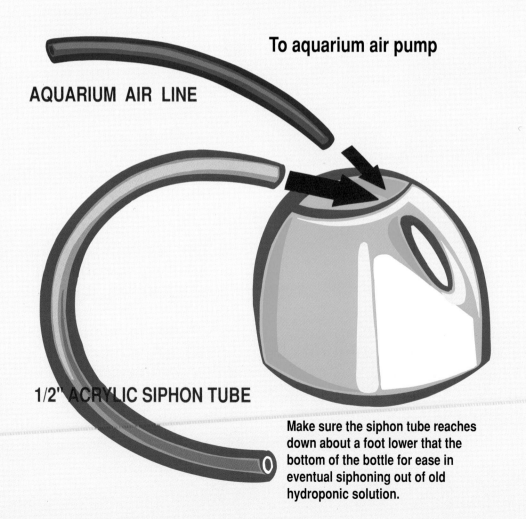

To aquarium air pump

AQUARIUM AIR LINE

1/2" ACRYLIC SIPHON TUBE

Make sure the siphon tube reaches down about a foot lower that the bottom of the bottle for ease in eventual siphoning out of old hydroponic solution.

STEP 2: Fill the jug with a growing medium, crushed lava rock or pea gravel, as well as clay pellets work well for this type of application.

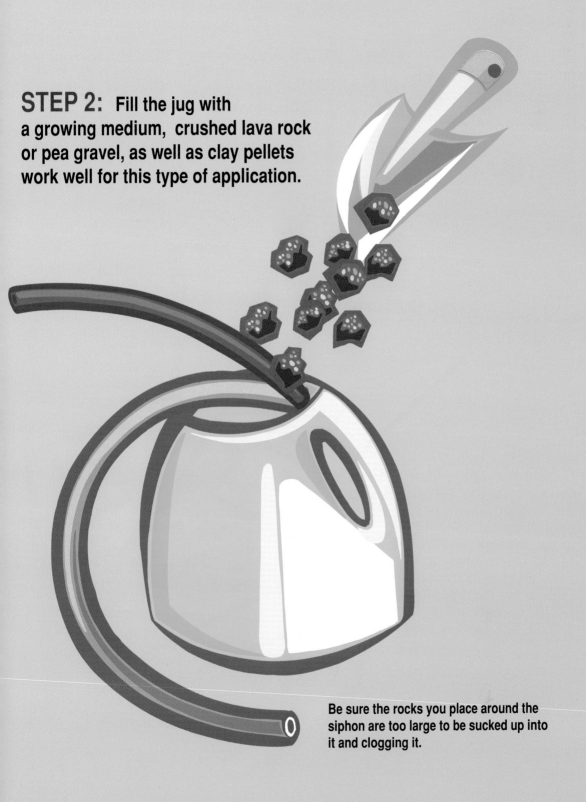

Be sure the rocks you place around the siphon are too large to be sucked up into it and clogging it.

A Sunny Delight plastic gallon bottle, or gallon milk jug works perfectly. FILL the jug with crushed lava rock in 1/4" to 1/2" chunk. This type of rock is available in 2 - 5 quart bags sold as "ornamental horticultural rock" to put on the top of soil in potted plants. Pea Gravel or clay pellets work also.

Make sure the grain size is too large to be sucked up by the SIPHON DRAIN TUBE.

To aquarium pump

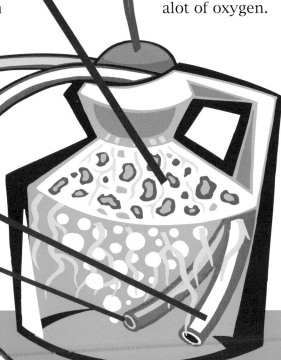

With a Sunny D bottle, the rising air bottlenecks at the top of the root mass, where the roots absorb alot of oxygen.

Position the siphon-tube, (acrylic tubing) and air tube through the handle of the jug, and down to the bottom as shown. Put the siphon to the bottom edge to keep it's mouth unobstructed. Position the air tube in the middle for even aeration DO THIS BEFORE PUTTING THE ROCKS IN!

The bubbles will rise, percolating through the lava rocks, creating a frothy, churning environment excellent for roots to uptake nutrients.

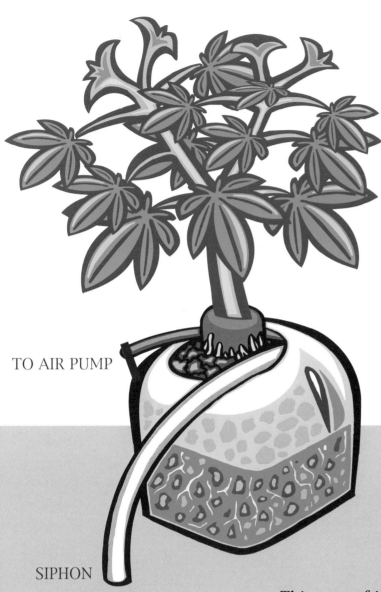

TO AIR PUMP

SIPHON

When the plant has grown a bit, it's roots permeate throughout the rocks forming an spongy mass in every available crevice.

Now the jug is running optimally, as air is forced through the encompassing rootball.

One aquarium pump can usually handle two or three gallon jugs.

This hydroponic method is simple, cheap and effective. It requires little or no maintenance besides the changing of the hydroponic solution. Just keep the pump running all the time.

This type of jug is much quieter than other aquarium-pump powered drip systems, as it does not gurgle but very softly.

Any type of gallon or larger jug can be used in this method, the tubes do not need to be inserted through a handle, they can be held in place by the weight of the rock medium and eventually the root ball, which will literally tie all the contents of the jug in place.

PUMPING THE AIR

Use a common aquarium pump to power the hydro-cells. One pump can handle 2-4 gallons of volume, but - generally the more air the better, especially during budding.

Use "T" valves to run more smaller bubblers of of one pump.

There are also "gang - valve" type double and quad valves with individual shutoff switches.

OTHER TYPES OF BUBBLING DEVICE

1.

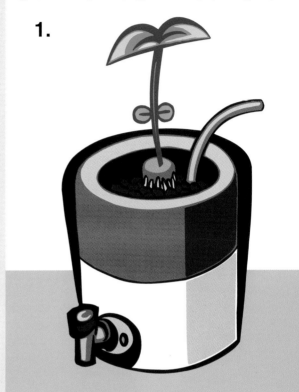

This device is made in the same way as the jugs, but this time with a common water cooler jug with a spigot on the bottom. The spigot saves what little time and trouble it is to siphon the solution out with a traditional siphon tube. The ultimate in simple upkeep.

2.

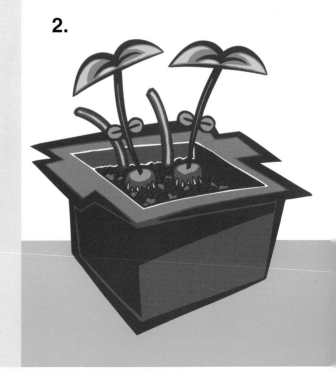

Here is a device with multiple plants in a square plastic storage bin. Use bigger bins and containers for bigger plants just be sure to have one air line at least for every 3 gallons of volume.

Keep bubble bottles 1/2 to 2/3 full. This keeps the nutrient concentration at a nearly constant level. If the level is allowed to drop too far the whole of the nutrient load will be occupying so little water that the salts in the solution will make it harsh for the plant to bear, and affect it's output, growth and quality.

If the level is kept too high, the tops of the roots won't breathe as well..... though - if a watering must be skipped, the bottle can be filled to the brim, as a day or two of too much won't kill the plant.

HYDROPONIC PH:

Hydroponic solution should remain at least between 5.5 and 7.5, and preferably between 6.0 and 6.8. At the recommended PH, the plant is more able to absorb nutrients, light and air across the spectrum. The hydro fertilizer should make the water acidic enough for about a week, then a little more fertilizer, or dissolve two aspirin tablets in a gallon bubbler.

Monitor the ph with test strips, available at your local spa/pool store, aquarium or hydro supplier.

For any hydroponic fertilizer to work it MUST contain, aside from the normal NPK rating: CALCIUM, MAGNESIUM, IRON. SULPHUR, ZINC, MAGANESE, COPPER, and BORON.

These are the other major elements the plant requres to maintain optimum health

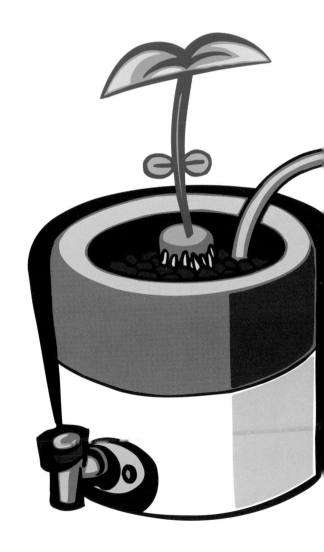

Passive Hydro Systems

Passive hydroponic systems can be made as well if a simple, easy to maintain system is desired. The concept is using a medium that is absorbant enough to soak solution, or wick it up into the root area. The example below is made out of two ceramic cylinders, one wide and shallow, one taller. The bottom reservoir holds the soluiton which then soaks up through a mixture of PEARLITE and VERMICULITE.

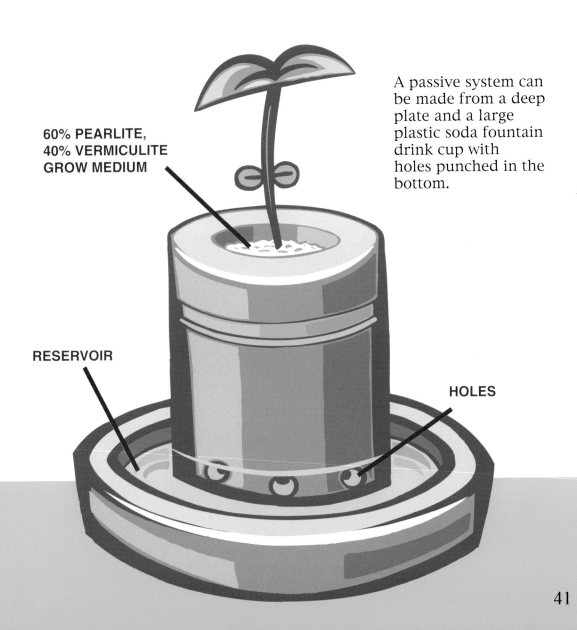

60% PEARLITE, 40% VERMICULITE GROW MEDIUM

A passive system can be made from a deep plate and a large plastic soda fountain drink cup with holes punched in the bottom.

RESERVOIR

HOLES

41

A good looking passive hydro unit can be made by putting a tall terra cotta pot into the bottom water catching piece of a larger pot, as shown below.

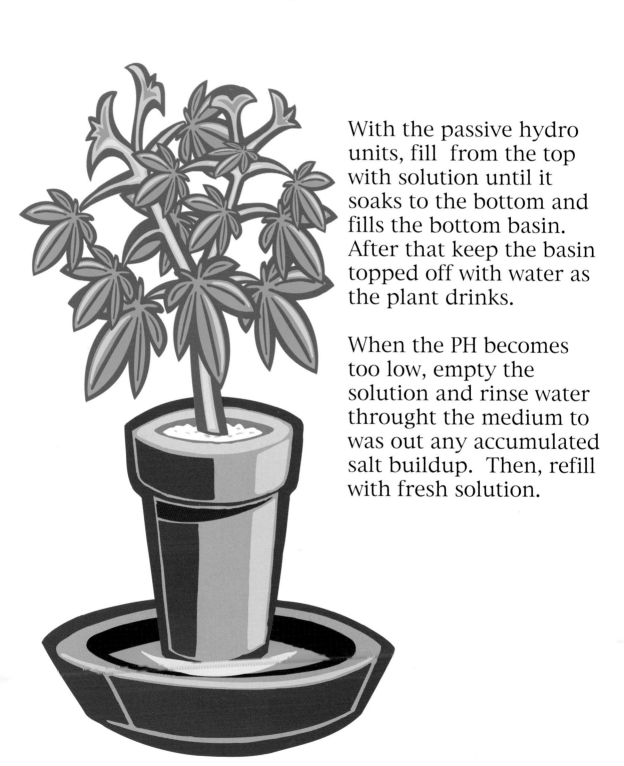

With the passive hydro units, fill from the top with solution until it soaks to the bottom and fills the bottom basin. After that keep the basin topped off with water as the plant drinks.

When the PH becomes too low, empty the solution and rinse water throught the medium to was out any accumulated salt buildup. Then, refill with fresh solution.

SOIL GROWING
GROWING AS NATURE INTENDED

Use soil that is not too heavy or full of clay. If purchasing soil, there are many excellent premium organic blends available fortified with earthworm castings, mushroom compost, forest floor compost, kelp meal, blood and bone meal, fish, sea bird guano and bat guano.

The more soil, the more size and yield. Therefore, get bigger pots, in the 3-5 gallon range, esp. if growing only a few plants. Cheap brown nursery pots come in many sizes and will last a few seasons.

If you prefer you can make growing containers by hammering some scrap plank together, and lining it with heavy gauge black plastic, then filling the container with soil.

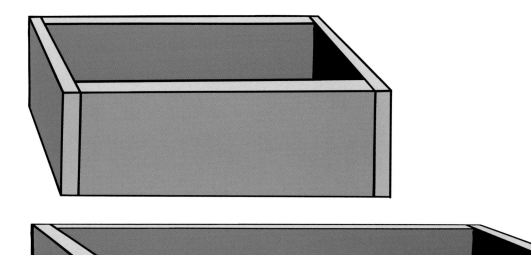

The best way to recycle is to reuse materials as-is for a new use without reprocessing. Look around the house, at durable containers available in many different sizes, shapes and volumes. Use different sizes for different plant stages and applications.

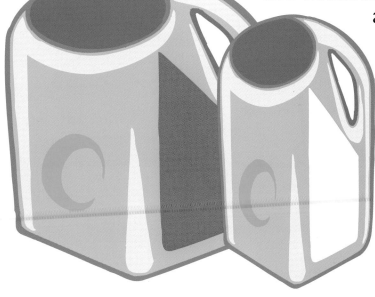

Do not keep soil grown plants sopping wet, as if more water all the time will help that much more. Plants like the soil to almost dry out between each watering. Water enough so that just a little water collects in the bottom, half an inch or so. Let the plant suck up almost all of it, repeat. For some reason plants like the rush, and their roots must be able to breathe - especially at the crowns, or tops of the roots.

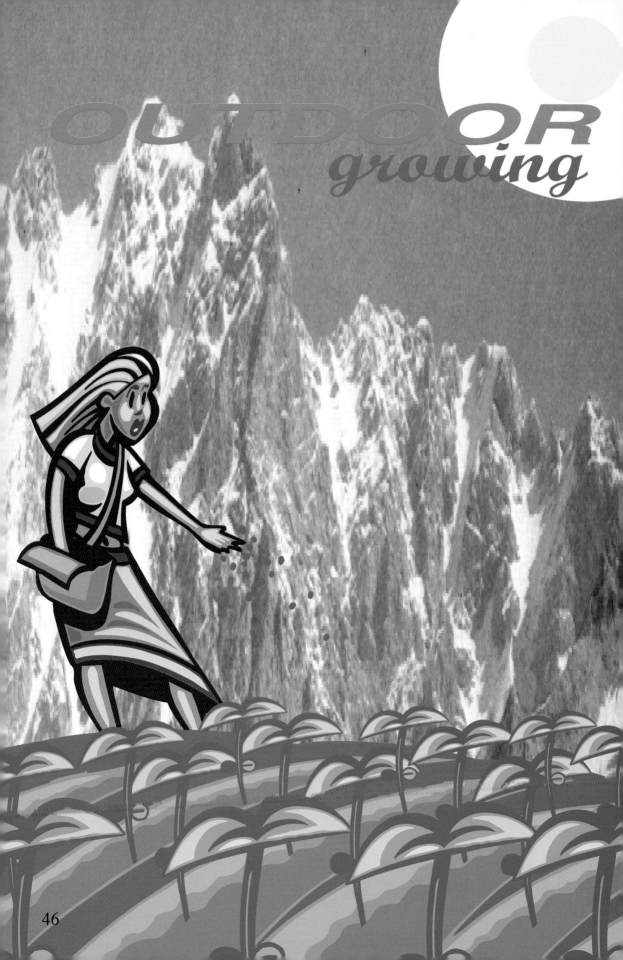

OUTDOOR *growing*

Dig a 5 gallon or so hole and fill with premium soil, or mix in nutrients to existing soil before planting the seedlings. Fortify the soil, to ensure maximum growth and output.

THE SEASONS

When growing outdoors the plant needs nothing more than the natural cycle of summer turning to fall in order to stimulate the plants to bud. During late summer and fall the shortening of the days, and lengthening of the nights causes the plant to sense the closing of the season, and it fruits like any other crop plant ripening to perfection in the late fall. Start seedlings inside in the early spring to get a jump start, and when fall comes there will be more yield. In the meantime relax, and read up on your favorite subject.

PRUNING

As with fruit trees, pruning correctly and at the right time causes the plant to give more fruit, and makes the plant more vigorous. With correct cutting, yields can be almost doubled.

When the just forming leaves come out at the top of a stem, the stem will then split into two as it grows.

1.

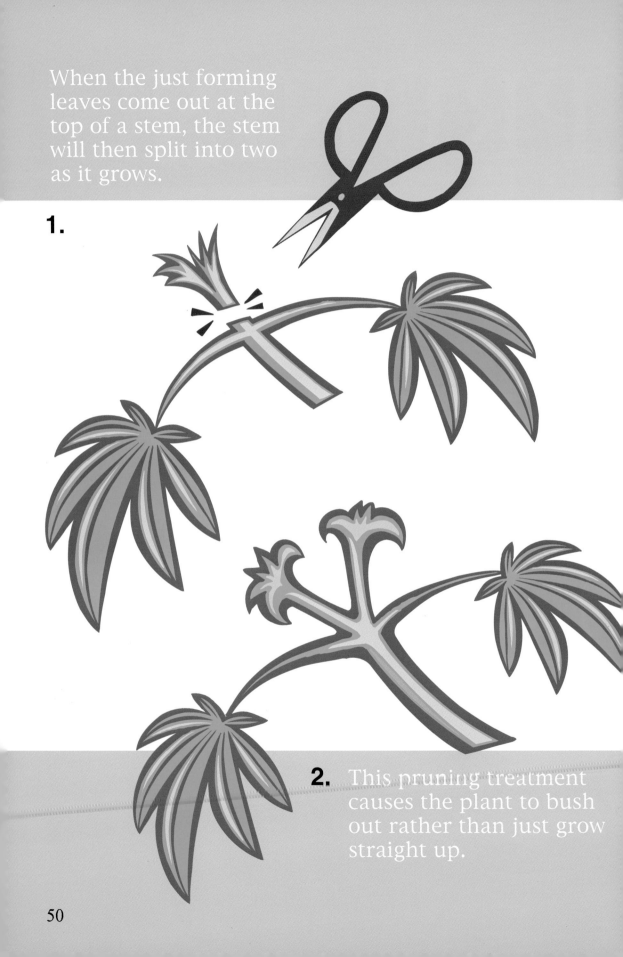

2. This pruning treatment causes the plant to bush out rather than just grow straight up.

Shown below are plants without the leaves to show the stem structure. This is the pruning formula for stocky, bushy plants with many many bud sites. If the plant is left to grow it will go straight up, like the one on the left. If it is nubbed off at the third or fourth node, it will branch out, allowing more bud sites to form and also moving more bud sites up to the top of the plant, in the more intense light.

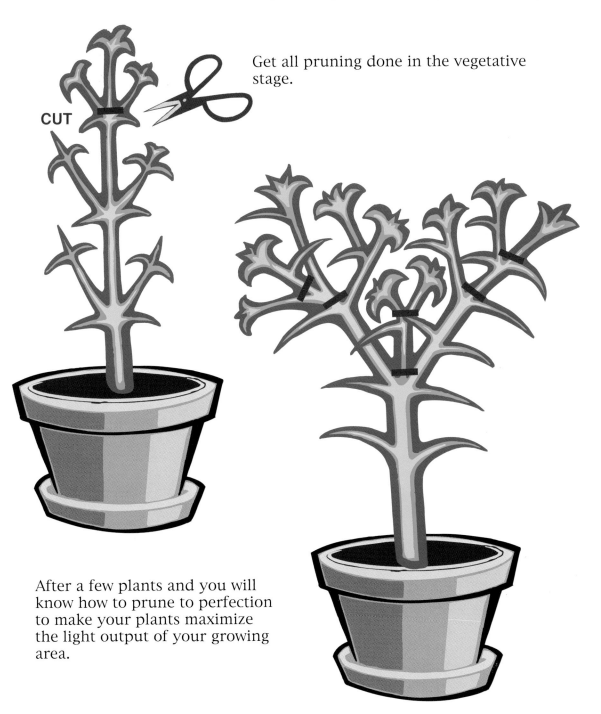

Get all pruning done in the vegetative stage.

CUT

After a few plants and you will know how to prune to perfection to make your plants maximize the light output of your growing area.

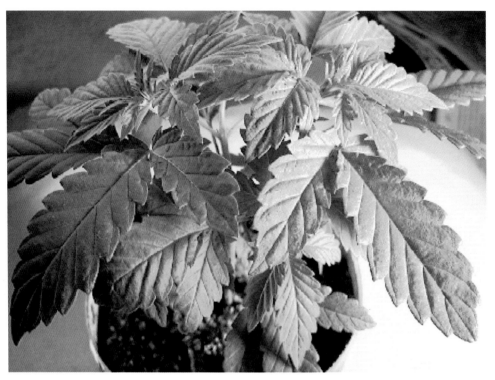

If the tip of the plant is clipped off,
the top branches out, forming
multiple tops - hence more bud sites,
as each will bear a cola.

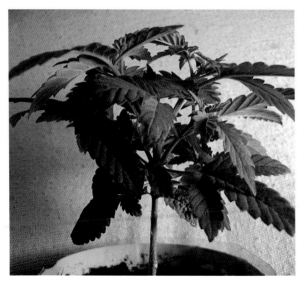

Pruning the plant so it will branch
out in this way causes most of the
buds to form in a layer at the top,
which is always bathed in the most
intense light. This makes a big
difference in how much of the
total yield is of the highest potency
and net yield itself.

The basis for the one leaf cover up is to clip all of the leaf blades off except the largest middle one. This allows for one to grow plants in a balcony garden, for example, and avoid their being identified. As

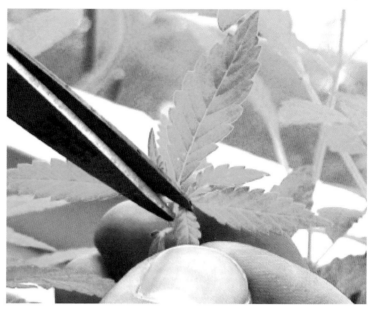

each leaf sprouts from the plant, trim off the side blades with a fine-tipped pair of floral shears. Make sure to be thorough - clip the blades as soon as they are big enough to get at. This channels all the plant power into the main leaf blade as it develops, making it a bit fatter and more capable of supporting photo-synthesis. It goes without saying that yields from this type of plant are smaller than they would be if they were left alone, but the technique is for stealth and is a godsend when there is no other way of growing. If the plants are well taken care and fed with premium soil and nutrients, as well as grown in a spot with a lot of sun, their yields can be up to 1/2 - 2/3 the amount compared with a plant of the same size which has been left alone. Amount of light is very important to this type of plant, as it's leaf area is minimized.

Above, a single leaf grove rises up. The plant in the left foreground is just about to start flowering. This grove was grown with a dope-hostile individual living in the very house! The grower was diligent in cutting all the side blades off, and also growing other, colorful flowers and fruits along with these - drawing visual attention to every thing else in the garden.

If there is a normal plant that must be converted to the single leaf style, accomplish it over a period of a few days, cutting off the side-blades a few leaves at a time, starting at the top and working down. If a plant is simply stripped of all it's side-blades at once, there is a very high chance that it will drop dead.

The Stunting Technique

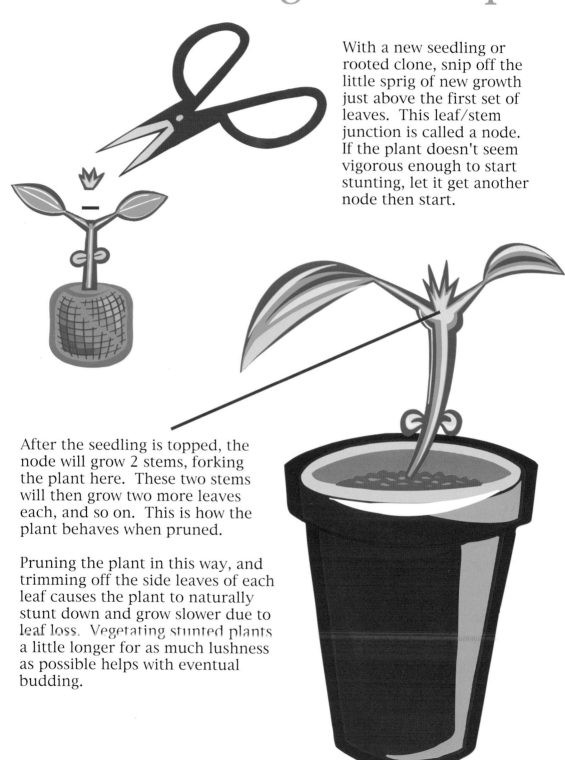

With a new seedling or rooted clone, snip off the little sprig of new growth just above the first set of leaves. This leaf/stem junction is called a node. If the plant doesn't seem vigorous enough to start stunting, let it get another node then start.

After the seedling is topped, the node will grow 2 stems, forking the plant here. These two stems will then grow two more leaves each, and so on. This is how the plant behaves when pruned.

Pruning the plant in this way, and trimming off the side leaves of each leaf causes the plant to naturally stunt down and grow slower due to leaf loss. Vegetating stunted plants a little longer for as much lushness as possible helps with eventual budding.

The basic concept of stunting, presented here, involves cutting the small, side leaves off - leaving only the largest center leaf.

After this treatment, the "classic" 5 or more bladed leaf has only one leaf. Now the plant looks more like a mint or other aromatic herb or flower plant.

1.

Use bonsai shears, or other fine-pointed floral shears or scissors.

Trim the side leaves off as soon as they are large enough to get at with your floral shears.

2.

Small nubs will form if the side leaves are not trimmed close enough. Simply trim the nubs when they are visible enough to clip off. They will no longer form when the leaf is mature.

Ideally, the trimming should start from the beginning, though it can be done anytime during vegetative stage.

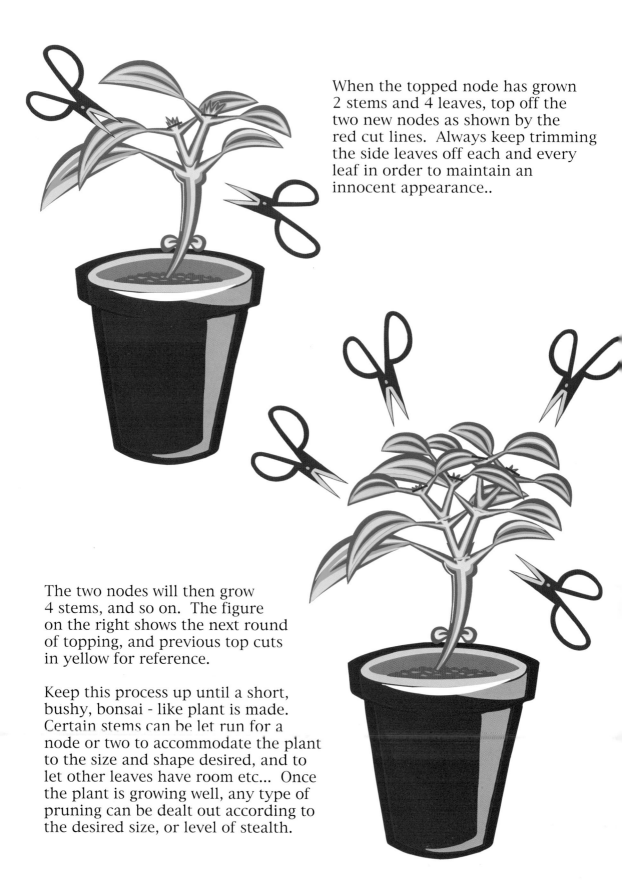

When the topped node has grown 2 stems and 4 leaves, top off the two new nodes as shown by the red cut lines. Always keep trimming the side leaves off each and every leaf in order to maintain an innocent appearance..

The two nodes will then grow 4 stems, and so on. The figure on the right shows the next round of topping, and previous top cuts in yellow for reference.

Keep this process up until a short, bushy, bonsai - like plant is made. Certain stems can be let run for a node or two to accommodate the plant to the size and shape desired, and to let other leaves have room etc... Once the plant is growing well, any type of pruning can be dealt out according to the desired size, or level of stealth.

This bonsai has been trained so the crown forms a ball at the top of a stem of about six inches long. It is ready to start it's flowering stage. Bonsai trained like this form little popcorn sized buds all over.

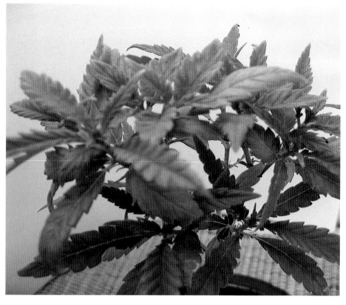

As soon as female flowers are detected, pour some water through the soil of the bonsai to rinse any accumulation that may have built up if the plant was fertilized with chemical fertilizer when it was

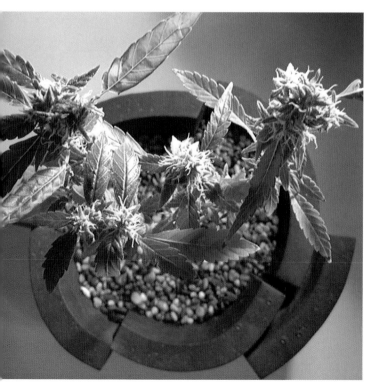

in vegetative stage - then apply premium bloom fertilizer two or three times during the course of blooming. Bonsai buds are often surprisingly potent, especially when they are grown in a quart or larger pot.

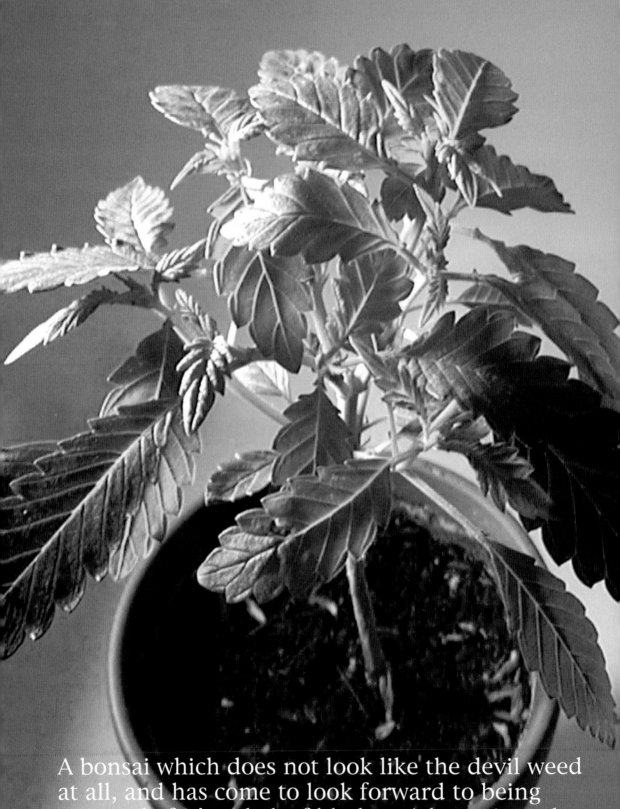

A bonsai which does not look like the devil weed at all, and has come to look forward to being stripped of it's side leaf blades. A bonsai can be grown on a desk, under a small grow-light bulb, or in a sunny window ledge. Convenient.

At right, is a nicely formed bonsai with big natural looking leaves - even though they are all stripped of side-blades. It is green and healthy, about 2 months old and ready to be flowered. If the bonsai is kept for a long period in vegetative stage, be sure to rinse the soil through with plain water to wash away

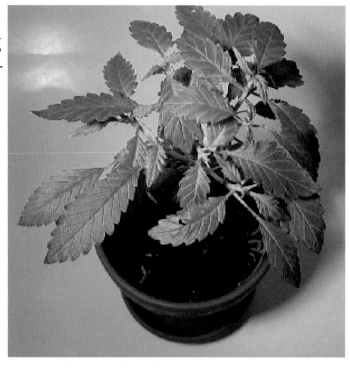

salt and chemical buildup in the soil. Or, simply wate with 1/4 strength house plant solution every time letting a little water drain away through the drain holes in the bottomof the pot. The trick is to find a good amount of your type of fertilizer to max out theizer to max out the

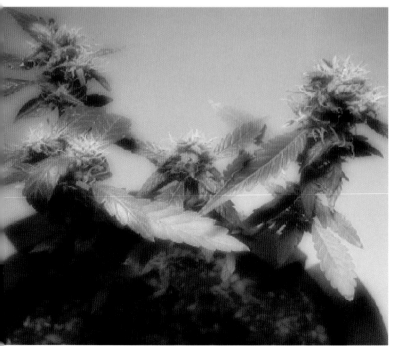

bonsai, but not to over apply, as this will cause toxic conditions to arise in the soil - burning the tips and edges of the leaves.

For their size and leaf area, little bonsai can give a surprising amount, with full potency if cared for closely along the way.

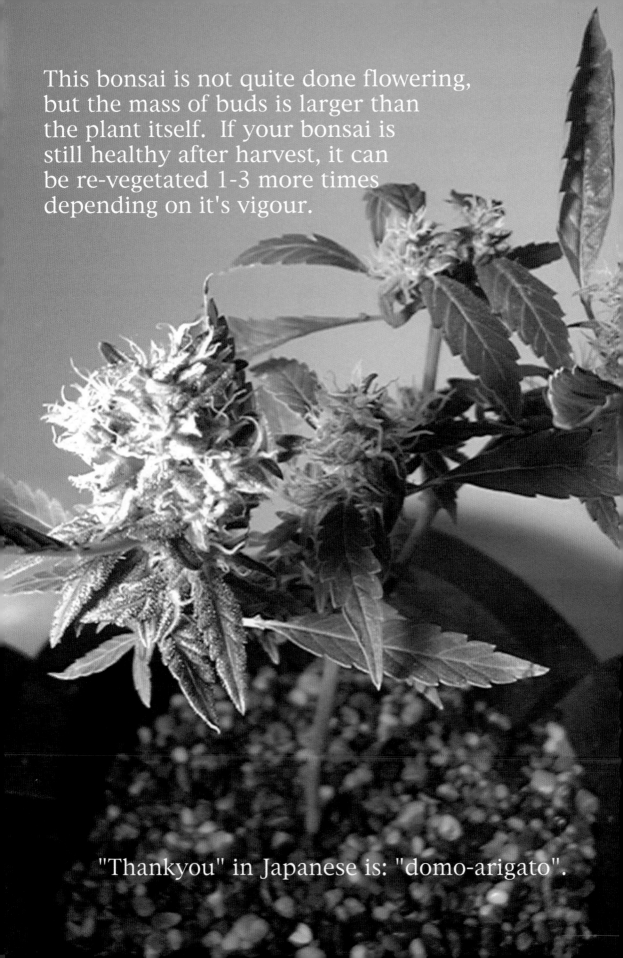

This bonsai is not quite done flowering, but the mass of buds is larger than the plant itself. If your bonsai is still healthy after harvest, it can be re-vegetated 1-3 more times depending on it's vigour.

"Thankyou" in Japanese is: "domo-arigato".

HARVEST
THE HIGH

HARVESTING AND CURING

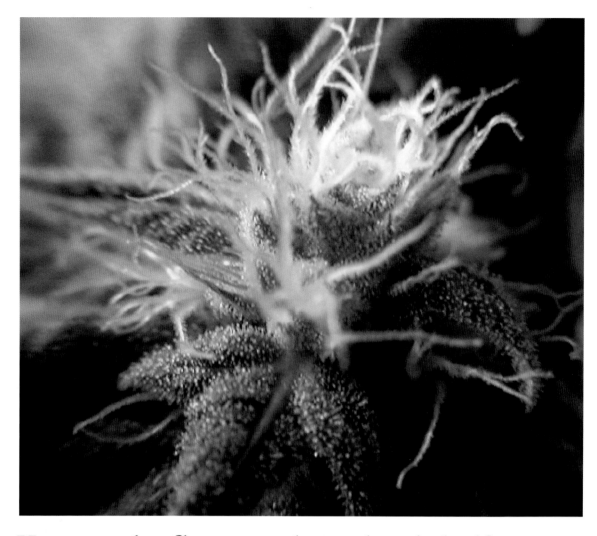

Harvest the flowers when aboult half, or
more of the white hairs turn red,
signifying the ripeness of each individual
bud attached to them. The goal in picking
and drying slowly, or curing, is to have all
or most the rest of the the hairs turn red as
well, before the earlier ones begin to lose
their potency. This specimin still has
perhaps a week before peak potency.

After a flowering period of about six weeks or when 50% of the hairs on the buds turn reddish, clip all the big fan leaves off the buds, and discard the rest of the plant. If the plant is harvested too early, or late, the potency will be lower as some of the active compounds are not as present, or have over ripened and turned into other compounds. Save and cure for smoking anything dusted white and crystally with THC - the most active ingredient.

Cut down the buds, as said before, when half to 60 percent of the hairs on the bud turn reddish brown - meaning those individual flowers have ripened. The rest of the flowers will ripen during the week or so it takes to dry the colas out. The object is to pick the buds at peak potency, so when they are dry and cured, all the rest of the flowers have ripened to peak potency - and most or all the hairs have reddened.

The object of "curing" is to dry out the colas at a slower rate than if they were simply allowed to air dry. This is done by keeping the plants sealed, or at higher humidity after cutting to allow for starches and sugars to change in the presence of the moisture.

This produces a smoother smoke.

A quick and easy way to lay a cure on potent kind, is to let it dry for 2-3 days, then put it in bags still somewhat too moist. Seal the bag for a further 2-3 days, then open and allow to dry almost completely. Put a small piece of citrus rind in the bag to keep fresh.

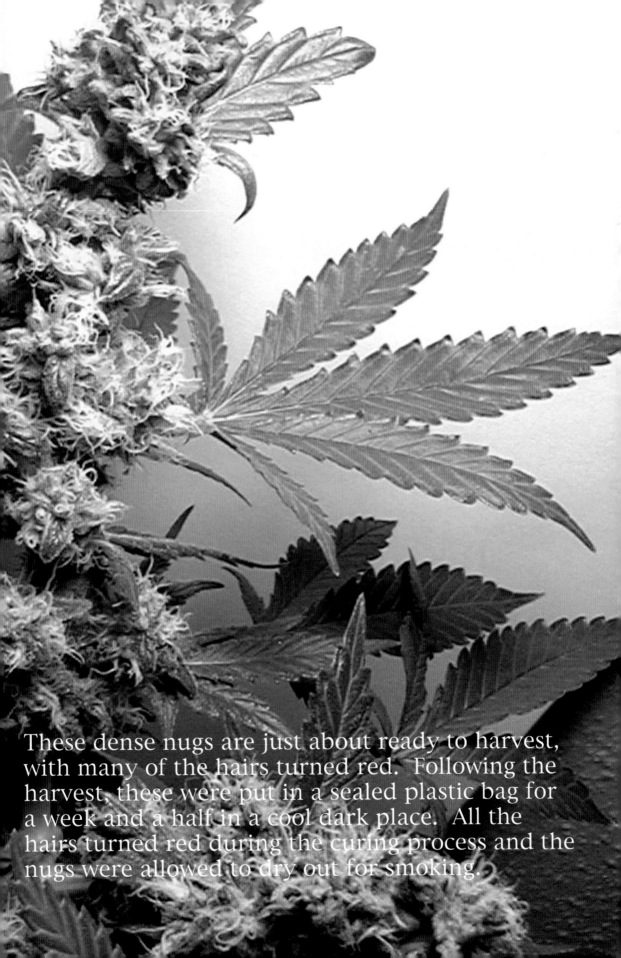

These dense nugs are just about ready to harvest, with many of the hairs turned red. Following the harvest, these were put in a sealed plastic bag for a week and a half in a cool dark place. All the hairs turned red during the curing process and the nugs were allowed to dry out for smoking.

Pestilence and other
PLANT AFFLICTIONS

One of the most common pests afflicting plants, especially indoors are SPIDER MITES. These pesky little critters look like tiny little spiders when grown. They lay eggs on the underside of the leaves. Each tiny egg sac sucks on the juices of the leaves like a vampire. This produces small white dots all over the top of the leaves. Beneath each dot is an egg sac. If left to infest, these sucking mites can drain a plant of it's vital juices.

Luckily, these and any other insect pests can be treated with several homemade or over the counter insecticides. PYRETHIN based insecticides are gentle and available at the drugstore. Pyrethin is a natural agent derived from common Geranium flowers and it works great. Treat plants as needed, to keep down the mites - or other insects. Be sure to spray the entire plant esp. the underside of the leaves.

INSECTICIDAL SOAP is also available over the counter. It is what it says, just a soap - which causes the bugs to dehydrate and die. Insecticidal soap can be made with a tablespoon of plain dish soap and a quart of warm water. Mix in a half a tablespoon of vegetable oil, and garlic juice (blend a clove with a little warm water and strain) for more insecticidal potency if required.

FUNGUS is the most common affliction of hydroponic plants and solution, though among them it is fairly uncommon if the solution is kept aerated, turbulent, and changed properly. Fungus is deadly and can be detected by white or grey flaky matter growing in the solution. Buy a commercial fungicide meant for hydroponics and treat the fungus quickly as it will kill the roots in short order.

OTHER TROUBLE AND REMEDIES

Besides pests, there are other problems from improper care or conditions. What follows is a handy troubleshooting guide of common ailments.

BURNT, BROWN TIPS, MARGINS AND SPOTS ON LEAVES:
This is the most common problem, resulting from over watering and over feeding, or if the air is too hot.
YELLOW LEAVES WHICH STAY ON THE PLANT:
Generally this is due to too much alkalinity in the soil, water, or hydroponic solution.
YELLOW LEAVES WHICH FALL:
Overwatering, cold shock.
QUICK DROPPING OF FOLIAGE:
Overwatering, shock, sudden changes in temp. and humidity, sudden change in amount or type of light.
SLOW GROWTH:
Cold roots, cold in general, overwatering, underfeeding.
ROTTING LEAVES/STEMS:
Fungus, overwatering, too much humidity.
WILTING:
Too hot, too close to light bulb, overwatering, downright soaking, too dry.
LIGHT GREEN LEAVES, PLANT STRETCHES UPWARD:
Usually too little light - or too hot, humid, or lack of nutrients.

Support the American farmer.

HEMP: Americans have the RIGHT.

Hemp is the renewable raw material for the production of many things, including paper, rope, fabric, feed, oil and many others. More paper can be made per acre from renewable hemp than not so renewable trees. Industrial hemp would provide the American farmer a valuable cash crop, easy to grow and pest resistant. Support your local industrial hemp initiative. Vote.